Exmoor Tales
Summer

Exmoor Tales Summer

A Personal Journal of Life on Exmoor

Ellie Keepers

Edited by Sarah Dawes
Layout and cover design by Oliver Tooley
Interior font – Garamond 14pt
Title font Black Chancery and Baskerville Old Face
Published by Blue Poppy Publishing, Devon

ISBN: 978–1–83778–004–4

For Ollie, Lexie and Zack
The brightest stars in the night sky.

Contents

A Moment to Remember 1

Walking in Their Footsteps 13

A June Morning 25

Blackbirds for Company 36

An Approaching Birthday 55

Windy Wildlife Wandering 69

An Unusual Night 78

A Priceless Treasure 84

Here is a Fence 94

A Note Regarding the Cover Illustration

Observant readers will notice that the front cover image does not appear anywhere in the text of this book. It does, however, appear in *Exmoor Tales - Spring* from the same series. A decision was made to use the image which best represented summer in the region, and the Valley of Rocks with a view of the sea below was by far the best choice, with the added bonus of being instantly recognisable. I hope you can forgive me.

<div align="right">

Oliver Tooley
Blue Poppy Publishing

</div>

A Moment to Remember

Standing atop the stunningly beautiful Molland Common, my grandson's little hand clutching mine, we listen for the distinct call of the cuckoo. It is a Tuesday in late May and, with the household chores completed and a swift picnic safely packed into our rucksack, we have ventured out along the wildflower-bedecked lanes as we normally do. I reap enormous pleasure from seeing our flower-covered banks, topped with dense hedgerows: the pinky-red of the campion; frothy, white cow parsley; the fading but once-vibrant bluebells; buttery-yellow buttercups; the pungent

wild garlic; and delicate white daisies; all of which adorn our lanes at some time or another during the spring and early summer months.

It is a dry, sun-filled day with a

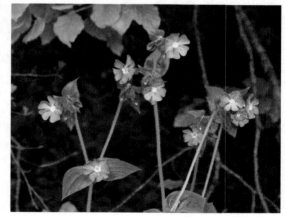

glancing breeze as we begin our wander, making our way down the sloping hillside. We carefully pick our path between tiny, star-like, yellow flowers, which shine out from between the cropped grassy areas. New bracken shoots are unfurling from the hard ground, and we stop to take a closer look before continuing towards our stopping place, down where the terrain flattens somewhat.

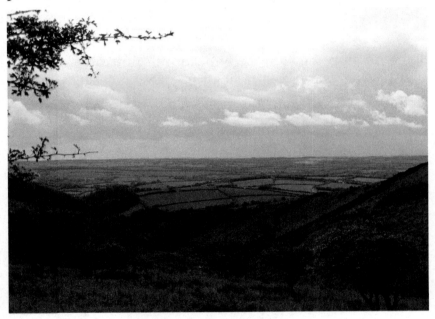

With small rabbit holes littering the grass, I continually have to remind my excitable companion that running is not on the cards and that a gentle approach, without a twisted ankle, is far more favourable on this part of the moor. I am loathe to dampen his eagerness to see the cuckoo, but safety up here is paramount.

Quietly, we watch our steps while listening to the continual warbling song of a skylark as it leaves the cover of the grass and soars into the blue sky. To hear the beat of its wings is music to my ears. How a tiny dot, way up above us, can produce a sound such as the skylark does, will always astound me.

As a child I would walk, with my older brother, across fields, purely to observe these amazing birds. He taught me so much about them and now I am teaching my grandson all I know. Hopefully, he will impart the knowledge to his children in later years – or maybe he won't. But, whatever the outcome, we have this time, here, now, and together, that we must make the most of. And so we watch with interest the antics of the little, but loud, brown bird.

Further down the combe we hear the piping call of a feisty meadow pipit and, as we crouch down to peer beneath the thorn trees, we espy two very quick birds flitting along the ground, in and out of the branches, a distinctive flash of white outer tail feathers showing as they fly.

The meadow pipits' nests are a great takeover favourite for the cheeky cuckoo and we've often seen the two together up hereabouts. My grandson has his own binoculars hung around his neck and has always been quick to spot the birds and other creatures with them. We talk about how he knows it's a meadow pipit and not a skylark and, with his questioning answers, we work through simple tips on identification that he can carry forward with him.

I have always told him that we are simply detectives, trying to work out what is what in the wildlife world, using

all kinds of things to help us: our eyes and ears, binoculars, books, the internet, the seasons, and other people. All of these things help to make it easier to discover what we are looking for, or looking at.

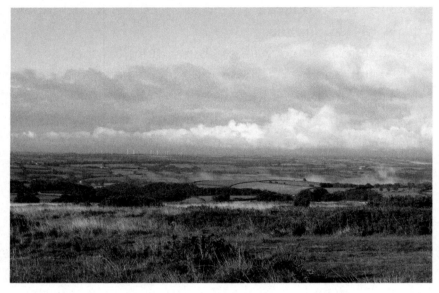

Deciding to stop awhile, close by to where the meadow pipits were spotted, we choose a spot to perch. My grandson's smile is priceless as I produce a finger of fudge from my zipped breast pocket. Always a go-to treat when we're walking or wandering the moors.

As the early summer sunshine blesses us from a cloud-free sky, we look across a patchwork of fields and farmsteads towards the South Molton road, and in the distance the wind turbines are spinning slowly. These monster towers have been a constant in my grandson's life, having been there since before he was born. He will look for them whenever we are out and about, and when he sees

them he knows we are not far from home, and so they have become a landmark for him. I wonder if they will be there for him in years to come, standing tall and calling him home. He calls them 'Johnny's Windmills'.

On many occasions I've sat here looking out over the land that I love and taking in the layout of the fields and hedgerows. I've sat, together with my husband, watching a wonderfully strong herd of red deer on a very cold winter afternoon as they made their way across the fields, the stags resplendent with their antlers, moving carefully around each other. Every year we visit several times to watch the cuckoos in their entertaining movement and flight, our pleasure renewed as the first cuckoo call is heard for yet another year. As each and every season passes, so the scene changes too.

But it's not just the land that changes, it's the feeling that the moor gives you that also changes. That, to me, is priceless. It's when you properly feel part of the moor, when you are at one with where you are at that particular time, when you know that you are home. Up here is my favourite place – there are extremely close seconds but this is where I've learnt so much and where I've seen so much. It's very special to me and it's why I need to share it with my grandson.

Settled into our resting place, we sit and wait, listening to the sounds of the moor. My grandson is currently working on a list of seventy tasks to complete, which was given him by his Beaver group. One of those was to go outdoors, listen for one minute, and record the sounds you hear.

It's an excellent task and one that he's now extremely good at. At times the silence is deafening, but it is punctuated with the calls of a stonechat, which sounds like two small stones being hit together. It always makes me smile to spot them. The rustic-looking little bird skitters about the tops of the gorse bushes that it frequents, drawing our attention. It is more than happy to sit still and keep us company.

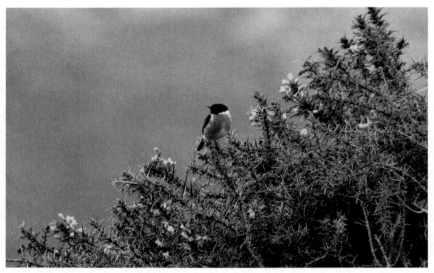

Skylarks soaring high with their constant song, the plaintive mewing of a buzzard, the lowing of cattle – and then the clattering call of a cuckoo in flight! We spot it about fifty yards from us, and I make sure that my grandson has sight of this stunning bird. Hawklike in its flight, it swoops from tree to tree, keeping close to the ground, seeming to prefer the topmost branches for landing on, which is ideal for us.

With his binoculars trained on the cuckoo, and hearing the bird making its distinctive call, my grandson can hardly contain his excitement. I'm whispering to him constantly while he watches, explaining how special this sighting is and how some people have never been lucky enough to see a cuckoo. Here he is, at seven years of age, witnessing not only the call but the bird itself, in all its glory, not fifty yards away. We watch with interest the pattern of its flight and try to guess which tree it will choose to fly to next; we listen to its peculiar call as it flies, and observe its interaction with the feisty meadow pipits. It is amazing to be able to share this moment with my grandson, as we've shared so many others. We've seen four cuckoos

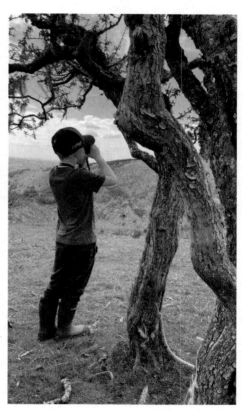

at once up here, filmed their flight, and recorded their calls, but today it is just one lone bird. But one is enough. Eventually, the blue-grey cuckoo with its dark-striped breast flies off down into the combe and away from us,

and we are grateful for being able to share a half-hour or so of its company.

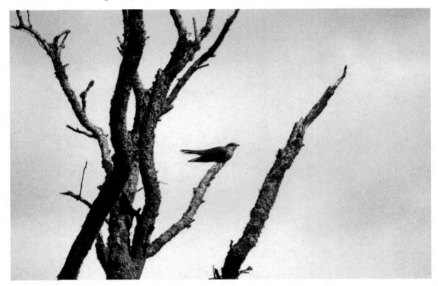

With the cuckoo gone, we sit and try to spot the sprightly rabbits on the opposite hillside as they move about their burrows, and we take in the view of patchwork fields in front of us. The panoramic scene stretches for miles and miles, the moorland falling away, with lush, green pastures taking its place. Vital hedgerows are the stitching that hold the colourful patchwork in place, providing homes for the wildlife of Exmoor, sewing the land together. I love to see the hedge-layers at work; theirs is an art form in itself that makes way for the new. I know that out of the bare chaos of the cutting and laying will come order, new growth, new life, and new beginnings for the flowers, birds, and small mammals. It's with this thought in mind that I have one more scan with the binoculars, checking for any

red deer we may have missed on the heather-covered moorland below us. Spotting grazing cattle and the odd Exmoor pony but no deer, we move our bodies, unfold our legs, and begin the wander back up to the waiting car.

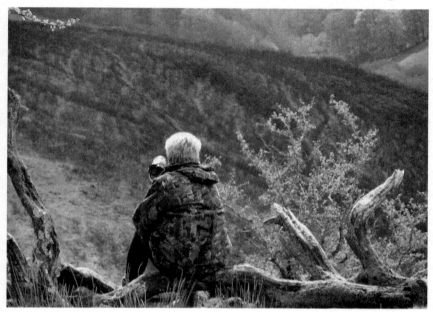

On this part of the moor, you'll find some small, fallen trees which are ideal to perch on, should the fancy take you. There are some weird and wonderful shapes to their small and characterful trunks and you'll often find me using one as a seat, binoculars in hand, as I scour the moor. There's one particular stump of tree that fooled me no end one spring day as I sat looking down the combe. I was absolutely sure that I had sight of a hare, head in the air, ears proud and listening. It took a quick look through my trusty binoculars to see that it was, in fact, a tallish, thin tree stump. It's still there to this day and it will always make

me smile. I tell my grandson the story as we make our way along the rough tracks made by the sheep, ponies, and cattle. He turns his head this way and that, peering at the stump, and his look says it all. Sometimes I wish I'd just kept quiet.

I sat here a few weeks ago with my husband, enjoying the peace and quiet, when an enormous and continual bellow rang out from behind us. Wondering who the owner was of such a powerful voice, we turned together to see a creamy coloured and very impressive bull wandering down the road towards our car, which was parked some yards away on the road. I suppose you could say that he was sauntering along towards the moor and his ladies, but he was on a mission. It didn't take us long to decide that perhaps a retreat to the car would be the order of the day and we began to circumnavigate other fallen trees and, giving the huge bull a wide berth, we reached the car in safety. Whether he was warning us that he was on his way and we were on his patch, or whether he was making a noisy entrance to let the herd know he was close by, we don't know – but we didn't wait to find out. He was coming through, whatever, and we weren't taking any chances. We still laugh about it now, as he was most probably very friendly and simply voicing an opinion.

Today, I am dismayed to find a new victim amongst the fallen trees, which was probably felled by the storms of a few weeks ago. Its freshly exposed roots reach up to the sky and, although not huge, it is still another small tree that has been lost. We investigate it as we pass by, measuring

the expanse of roots against the reach of its branches. As we do, the cuckoo catches our attention once again, having returned to the nearby trees. With one final look we leave it in peace and continue our climb.

Our lunch is calling – tuna for me and cheese for my grandson – so after some discussion we decide we'll spread my homemade camouflaged rug out and devour it on the bank in the warm sunshine. As we pick our way through rough tussocks of dry moorland grass, dark green sedge, and newly emerged bracken, a little warm hand finds its way into mine for the final part of the uphill climb.

"I love spending time with you in the country-side, Nana," a little voice says, which grabs my heart and chokes me up somewhat.

"I love spending time with you too, Z, wherever we are, but especially out on the moor, and that was a lovely thing to say," I reply.

It's all I could ever ask for and my grandson had made my day, and more. The smallest comment can make a huge

impact and it will be a moment I'll remember and treasure forever. Another moorland memory made above Molland.

Walking in Their Footsteps

Deep in the wooded Barle valley you'll discover a network of wonderful pathways and tracks that criss-cross over the land. Many of these are ancient, having been trodden by those that inhabited the areas around Dulverton many years ago. Those dwellers way beyond Dulverton and Hawkridge and out to Withypool, Winsford, and even further afield, would have frequented them. The stony, rocky paths and dirt tracks would have been the only means of moving about for some, whether on foot, by horse, or with a horse and cart. Many, many miles would have been walked or ridden, but back in the day, this was normal and a means of getting from one place to another, whatever the weather. I so very often try to put myself in the boots of those that have gone before and imagine what life was like back then. I love to think that the lie of the land and the bare bones of Exmoor haven't changed a great deal.

I came across a photo a couple of days ago which showed a view over and across Hinam Farm, which nestles in the valley. The farm was isolated and remote back in the

1800–1900s and, to my eye, the view is not greatly changed, which pleases me no end. We will often park close by to Hinam Cross and take a wander down the steepish lane – resplendent with daffodils in the spring, or in summer a mass of cow parsley, and a sight to behold in any season – headed towards the mighty River Barle.

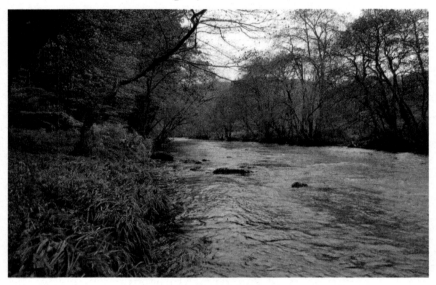

Reaching the bottom, over a rough and sometimes muddy track, a right turn takes you on a riverside wander to Marsh Bridge, or a left will see you reaching Castle Bridge, where the choice is yours as to which path you take. I believe the lane leading down to Hinam, with its ancient banks and hedgerows, is hundreds of years old and dates back to somewhere around the 1600s.

Trundling down the lane towards the Barle, I'm able to throw myself back in time and walk with those who used the lane as part of their daily lives as the centuries passed.

I also feel close to the past when I'm crossing any of the bridges on Exmoor. Running my hands across the stonework, stroking the age-old pieces, and peering over midway into the tumbling waters below, I ask myself who has crossed the bridge before me, where were they going, what were they carrying? Was it to a local market or simply making their way to school?

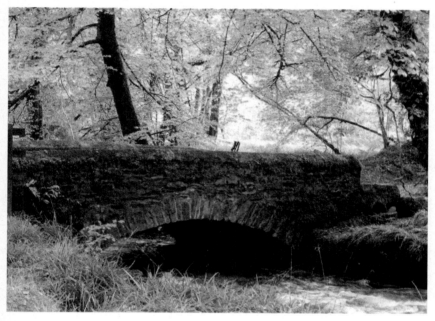

These stone structures have been tested time and time again, carrying the moorland people and others from one place to another, taking them from one side of the crystal-clear waters to the land on the other side. As in life, we all have a choice as to whether we cross the proverbial bridge. Some will stride out, confident in their step, and embrace what meets them on reaching the other side; others will be

hesitant, wondering if their choice will make a difference or hinder them. I find myself somewhere in between. I don't sit on the fence by any means but I will consider my options carefully before making a confident step forward.

But I digress, and I blame my thoughts wholly on the peaceful and calm environment of Exmoor, which allows us time to ponder.

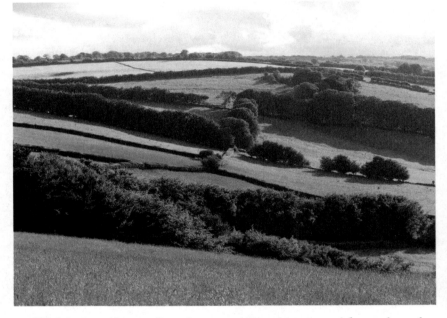

Waking early on Sunday morning it was evident that the day had dawned warm and welcoming. There was no discussion or decision between us; the decision had already been made last night before we slept. Pulling back the curtains onto a waking Exmoor, we downed a quick cuppa, donned our clothes and boots and, deciding that a

waterproof outer layer would not be required, we left the cottage in peace to begin her day.

Eventually deciding to drop down towards the Barle through dense woodland, we crossed four or five fields, leaving our footprints in the greenest of wet grass as we walked together over the pastures that we know so well. The incessant rain that had fallen during the inky night-time hours had left the surrounding countryside smelling fresh, and the colours of Exmoor were vibrant, showing us their very best. The newly emerging beech leaves on the bordering trees shimmered in the morning sun, their stillness making even the smallest movement, from the birdlife and sheep, stand out and draw our attention.

On reaching the woodland through a rather new gateway, we found the ground beneath us spongy, giving us a definite spring to our step. As we disturbed the rich

leaf mould of the woodland floor with our silent footsteps, glorious birdsong bombarded our ears, filling the woodland from the base of the trees to the very topmost bough. Above all the cacophony of noise, the drilling of the woodpecker rang out true and clear, letting us know of his presence.

With the lesser celandine, primroses, and wood anemone having completely gone over, the last of the bluebells were following suit with a speed that befitted the coming of the end of May. Together with the ramsons, they will be gone before long, their scent hidden for another year. The seasons come and go and yet these

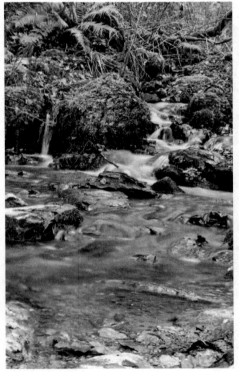

woodlands will always give pleasure with their birdsong, their flora, and their fauna, whatever the season, whatever the weather. They never disappoint.

We were headed towards Marsh Bridge that morning and, dropping down towards the smaller Castle Bridge, we tarried awhile, peering into the tumbling brook. Here, the damp moss clings to any surface it can. In the

autumn months the contrast between the browns, oranges, and yellows of the season, and the glowing, green moss is a sight for sore eyes. In summer it blends seamlessly into the greenness of the greens, giving a verdant feeling to the base of the woodland; it's clean, it's green, and so very fresh. Following the endless movement of the river as it fell and tumbled over boulders both round and flat, we made our way along the bracken-edged track.

Sometimes the path took us upwards, with the incline affording far-reaching views across the river. Within minutes we were trundling down again, level with the Barle, and being entertained by dippers and grey wagtails, busy in their quest to find food for their hungry offspring.

The grey wagtail is swift in its approach to the mission and doesn't stay still for long. With its tail bobbing up and down as it flits and flies from rock to rock, it becomes quite mesmerising and hard not to observe. We felt tired and fatigued just watching its antics!

Down by the river, the hazel and beech trees were on their way to being fully open, their almost citrus-green leaves having unfurled from their tight buds to meet the world again for another year. However, it was still possible to keep an eye on the birds as they swooped from branch to branch and, indeed, to follow the grey squirrels as they busied themselves on their early morning foraging. We took sight of a treecreeper as it flew towards the trunk of a large oak tree to our right, its white underparts gleaming under the open woodland canopy as it moved. It settled on the trunk, clinging to the bark, making its way up the tree.

If we hadn't have spotted it flying, then we'd have missed it, its camouflage against the bark being so very effective. We marked it up as a bonus sighting.

As we neared the red-and-white of Marsh Bridge, we kept our eyes peeled for the kingfisher that we've seen here on many occasions. That flash of distinctive, colourful turquoise and orange plumage is always exciting, no matter how many times you've witnessed it. The last time we walked this way, I glimpsed the kingfisher but my husband didn't and I don't think I've yet been forgiven for not alerting him to its presence. Again, it's a quick little bird – a blink and you'll miss it – and, on that particular day, if I had blinked, then I would have missed it too.

I've noticed this week that the blossom of the may (hawthorn) tree has finally appeared. In my own garden I have rowan and hawthorn trees and both have come into flower at the same time. Only now will I happily shed a layer or two when the sun is shining. As the old saying goes "Ne'er cast a clout, till may is out". With their strong thorns and delicate-looking, creamy-white flowers, the hawthorn is able to withstand the harshest of environments and I find it my most favourite of trees.

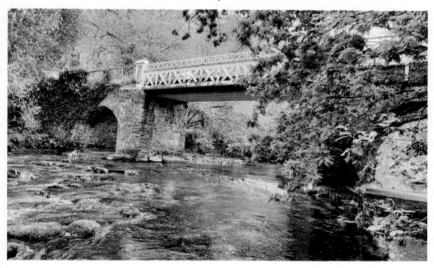

Reaching Marsh Bridge, we found it occupied with a few cars. The occupants seemed oblivious to the multitude of small flies swarming above the river, on which the grey wagtails were gorging themselves. We perched on the bank, a little towards the bridge, and watched them with a hot coffee and a finger of fudge, which I produced from our rucksack. Many times have we sat there, watching the dippers for hours on end, bobbing and dipping as they feed

their young. Alas, they were not in sight that morning. While we sat, we debated whether to retrace our steps or to take the lane part way, up and over past Northmoor, before dipping down towards Hinam. Deciding on the latter, we were off again, in search of the pretty roe deer that we so often catch sight of along that route. There is often just one that we espy in a field to our right, and it's only visible from the downward approach to Marsh Bridge.

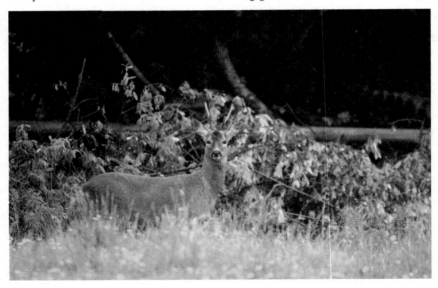

Only a couple of weeks ago, we were travelling homewards and spotted a lone roe deer trying to climb the steep bank at the side of the lane, without success. It had obviously heard our approach and panicked somewhat. Slowing to a stop while it sorted out its best means of escape, I sat with bated breath, hoping against hope that a car would not come down the hill, round the sharp, blind elbow of a bend, towards us. All was good; danger was

averted, and the deer found a gap in the dense hedgerow a few yards up the lane. They are always a delight to see with their shiny, button-black noses and white tail marking.

Networks of pathways had been crossed and wandered. The river and its surrounds had been walked and, once again, we walked in the footsteps of our ancestors from hundreds of years ago. Not a tarmac lane back then, but a rough dirt track into Dulverton, three miles from the rise above the town and nearly to where we stood, overlooking a patchwork of fields that are as old as the hills. Children would have ridden to school on a pony or horse, if they were lucky, a bag of feed over its withers and with stabling near their destination. As young as five, some walked the three or so miles to school, whatever the weather, sometimes accompanied part way until they'd experienced it for a couple of years, up hill and down dale, taking it, literally, in their stride. It brought to mind my grandson, who had been taking part in a "Walk to School Week" that week. After five days of walking to school he received a much-anticipated certificate for his perseverance. I'm told he was very excited about receiving it, but it's a far cry from the children of the 1900s and before.

Always on my questioning mind, I'll probably ponder the lives of those that walked and worked the lanes and tracks we now wander, for many years. As they say, "you're never too old to learn", and I've no doubt that our cottage, built around the turn of the 1900s, will help me along that pathway.

As the first spots of rain were felt, we quickened our pace towards the shelter of the woodland tree canopy, homeward bound.

A June Morning

It's six o'clock in the morning and I find myself wandering across the lush, damp fields on what promises to be a very warm June day. It's my favourite month, with its long days and evenings that lengthen as each day passes. With my lemon-and-ginger tea safely slopping about in my usual travel cup, I'm headed for my favourite gateway, three fields over. Once there I'll climb up the gate and perch on the solid, wide, round post, and sip my tea amongst the peacefulness of the morning.

Walking over the dew-laden grass, on a well-trodden trail, I look back to see the tracks of my footsteps marking a pathway to my destination. I enjoy the feeling of being the first person to wander the fields that morning. There's something special knowing that you've probably only shared it with the wildlife so far that day.

Looking across the valley towards the moorland, I disturb a buzzard on the slope and he lifts himself off the ground with powerful wings, leaving his morning meal behind. He virtually disappears against the backdrop of trees but will probably return once I've passed. There's just

me and the birdsong as I finally reach where I'm headed. It filters out of the trees and hedgerows, each shrill note vying for attention, each one trying to be the best and loudest, and each one filling my heart with joy.

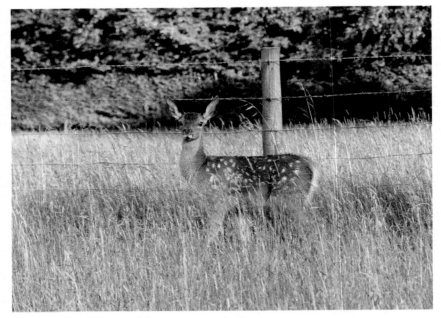

Once up on the gatepost I'm higher than the hedgerow and can see way across the field, which has a slope to one corner. From here, when I'm concealed behind the hedge, I can watch the red deer make their way from the woodland cover, leaping over the fence and onto their grazing ground. I've already checked that I won't be disturbing them this morning and am happy to perch, and watch the day begin, with my tea.

There's a blue tractor busily working in one of the far fields. I can just about spot it in the distance as it silently

makes its way up and down the hayfield. I can see it but I can't hear it; it's extremely peaceful. However, I know that I can't stay here for long as I have to wander along to our neighbours. They're going away for the night and we've been given charge of the animals, so a handover session will be necessary before they go. I'll make the most of my morning wander before I head off though.

Halfway up my gatepost a dark green ivy is climbing, clinging to the wood with its tiny, sticky root hairs. Having not reached the top of the post in years, it doesn't seem to be a very speedy grower but it gives the gateway character and charm in its own way.

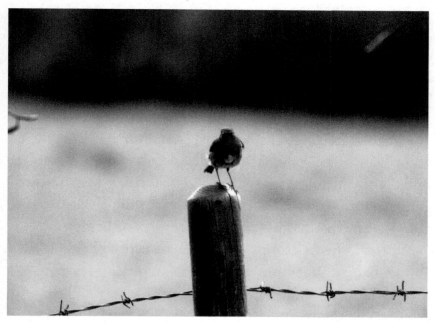

A robin also frequents this gatepost and I've seen him bobbing about on the top of it on many an occasion. At

one time there used to be a hanging bird-feeder next to the gate, and I've often wondered if he remembers it was once there and comes by to check every now and again.

I have to make tracks, literally, back home and decide to go upwards along the field so that I can make even more trails with my footsteps. The early morning sun is warm and the air is still as I climb down from my lookout post, jumping the last bit just for the sheer joy of being out.

With the fields having not been mown yet, there is an abundance of sunshine yellow buttercups and warm red clover popping their heads out from the now tall grass. I always skirt the fields and walk alongside the hedgerows at this time of year, not wishing to spoil the grass before hay time. It gives me the chance to listen for movement in the

hedgerows as I walk. The telltale rustle and swish of the grass, as I approach, will normally be a mouse or small rabbit but is soon quietened as I near and pass by.

Pheasants that clatter out of the undergrowth with wings beating will always surprise me and, with heart thumping, I'll clutch my chest and start breathing again as they sail away, never getting that high off the ground in their escape, and complaining as they go.

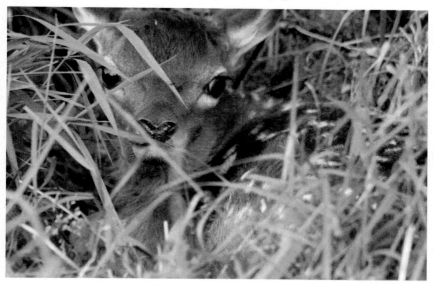

Walking this field last year, we passed a red deer calf curled up, under the beech hedge amongst the long grass and fresh bracken. It's huge, black eyes looked straight at us as we passed but we carried on walking, knowing that we didn't want or need to disturb it. The pretty little calf was virtually impossible to see but its long ears gave it away at the last minute. We very nearly didn't see it at all and I'm pretty sure I let out a small, whispered gasp on seeing it.

Once we'd passed, it was up and off. The warm indentation where its little spotted body had lain was left behind as it leapt from its hiding place and bounced across the field towards new cover.

We always worry on finding the babies as they will try to get over the fence and out of the fields if they're spooked or afraid, so we always ensure that a gate is left open for them at this time of year, so they have a means of escape. It's good housekeeping because we've witnessed far too many youngsters caught up in barbed wire fencing. It's not pleasant, but it's country life and we have to deal with it the best we can, hence leaving an escape route. The deer that frequent this field are canny, and both mum and baby seem to know the best routes to cover and safety.

Next to the wooden gate that I'm about to climb over, there is a tall beech tree; its branches seem to reach out further than is usual for the species. In the rutting season, and the weeks after, it's a challenge to pass under the tree without stepping on the crispy beechnut casings, which alert the deer almost immediately. Even though you've managed to creep across the field and make it to the hedge undetected, the beechnuts underfoot are a complete giveaway and one we could do without.

On the other side of the beech tree, in the adjoining field, is a small deer wallow. It's appeared over the years and is used regularly. The ground dips a little here and the rainwater sits for longer. Being right under the tree, it's more shady, and the sun doesn't reach it to dry out the mud patch that's now formed there. Deer slots of all sizes

can be seen imprinted in the mud both around the edge and towards the centre. It's always interesting to see who's been to visit.

Over the gate, latched with a metal hook and orange baler twine, I turn left and follow another well-trodden grassy track around the field. Normally housing the horses, the grass is shorter here and is edged with yet another beech hedge. Tall, nodding, purple foxgloves reach out of the banks here and the hum of bees going about their daily work is a given around the beautiful flowers.

Halfway along the hedge there is a distinct smell of fox and, indeed, they have been seen out and about in the fields. When we had the Beast from the East snowfall, there was

a trail of fox prints all the way along the edge of this field. As deep as the snow was, they were quite clear and quite close together. In some places it looked like the fox had dive-bombed the snow before the trail disappeared up the bank and into the copse.

My cup is empty, as is my tummy, and I need sustenance before going up the lane for our animal babysitting orders. We will have four horses to muck out this morning, a job I love to do, and then they'll be in the fields for the duration of their owners' absence. There will be sheep to count and check on twice a day, as well as entertaining the dogs.

The last time we took over, a large lamb had managed to ensnare its head in the fence between two lines of wire. My husband says he'll never forget how I straddled the

poor creature while attempting to free it. We managed it together, but it was a tough job as the wire had twisted into a noose which was wrapped around the sheep's neck, holding it prisoner. Goodness knows how it had managed to get into such a pickle, but with a shake of its head and body, and a quick rub from me to check all was okay, it sorted itself out a drink, and was off with the flock again.

As I reach home, I choose to go down the higgledy-piggledy slate and stone steps that lead from the top garden. They pass by the bird table, which is busy with blue tits and great tits, all clamouring for the restaurant-type fare that's on offer there. It is hard for me to miss the wonderful welcoming smell of bacon coming out through the low kitchen window. My husband is up and cooking breakfast and I'm ready to eat. It all smells amazing!

How lovely to be able to go for a morning wander and then come home to a bacon sarnie and a fresh-brewed coffee. It's a simple life we lead and simple pleasure is what it's all about. We really need to head off up the little lane for our orders but first things first; it's breakfast time, and I have a mouth-watering bacon sandwich waiting for me.

Five more minutes won't hurt, will they.

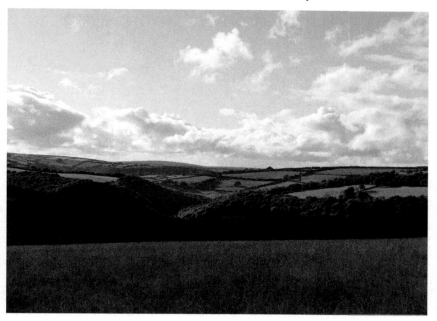

Blackbirds for Company

For three years we have fought to grow our own wild flower mini meadow, here in our garden on Exmoor. You would think it easy, living where we do, but that is not the case and it's been a labour of love.

Intending to make the most of our garden, a small part of which was a scrubby, unkempt area through an old gate, where we've been told raspberries and gooseberries once grew in abundance, it was decided that we would do our bit for the bees, bugs, and butterflies.

With a small wildlife pond planned for the furthest corner, we were away. It was properly cleared, raked over, sown, and trampled on and, each year, we've added to it as it has welcomed the wildlife, including toads, frogs, and newts in the small but functional pond.

This year, however, we've seen a turnaround and it's the best it has ever looked. It's a good job that I have patience as a gardener because it's been worth it. Amongst the grasses there are vibrant blue cornflowers, bright meadow buttercups, spreading yellow rattle, and purple vetch;

campion, teasel, corncockles, swaying mayweed, wild carrot, and mallow.

Along the narrow gravel pathway to the pond we have the burnt orange of fox and cubs growing freely. Every year, as it is prolific in the way it spreads, I thin it out but cannot dispose of it completely because I love it so much mixed in with the white daisies. It leads you along the path to the pond and asks you to "please enjoy the walk".

Fenced on two sides by our own version of a rail fence, low enough to rest our feet on when we're sitting on our bench with a cuppa, it's a calm and peaceful place to sit awhile and observe what we've created. It's from the wooden bench, placed in the corner of the garden, overlooking the wild flower patch, that I'll sit most

mornings with said cuppa, quietly collecting my thoughts, and contemplating the day ahead.

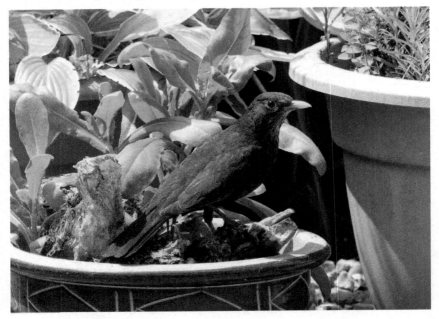

Tidying up our small wildlife pond area recently, I had some company. While a female blackbird picked out all the mealworms from the handful of food I had in my pocket, and which I'd scattered about for her, a cheeky robin sifted through the leaves I'd lifted out of the pond. I'd left them tidily on the side so that any pond life could make its way back to safety, but the robin promptly tossed them back into the water after inspecting each one. After three goes at tidying up the robin's efforts, only to have him fly down from the beech hedge and play exactly the same leaf-tossing game, I gave up, grabbed a cup of tea and watched them feed from my bench.

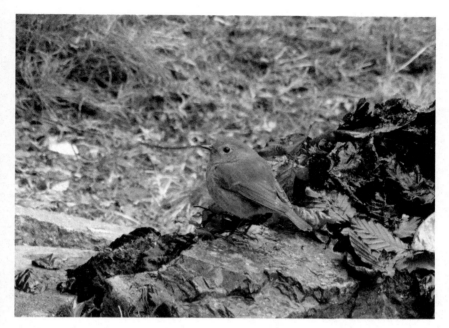

The bench also looks onto the beech hedge at the bottom of the garden, where it seems the female blackbird has nested and laid eggs, having found a stunningly handsome mate, with a distinctive white marking on his back.

Over the weeks they've both become quite friendly, following me around the garden picking up worms and bugs, as I work turning the soil. I began putting a few mealworms down for them, which I transported around the garden in a small, blue, plastic jug. They seemed to associate the jug with food and now, when I go to peg the washing out, they appear out of nowhere. They are there, at my feet, or perched on a fence post, watching and waiting for mealworms. Every morning and evening they

pay me back by singing their velvet song from the shed roof, just a stone's throw from the back door.

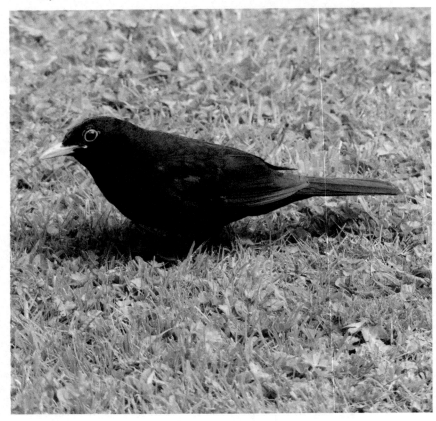

From my bench I've become used to tapping the blue jug with my fingers and scattering some mealworms for the busy parents. To be honest, I have enjoyed their company. Then two weeks ago they introduced me to their speckled fledglings and they too came down to feed, using the dense beech hedge as cover.

As the babies grew, so their parents became quite strict with them when they called for food. Urging them to feed themselves, their mum would open her pale-yellow beak as wide as can be, threatening them with a vicious lunge, should they bother her while she herself fed. Eventually they got the message loud and clear and began to come down to me alone, feeding very closely to my feet, a matter of inches away, and running under my booted legs as I rested them on the rail fence.

~

We've shared some peaceful times together over the past few days. Two weeks have now passed and as I worked around the garden today on my knees, weeding, the growing babies and their mum have worked with me, searching the turned soil for worms. They've been right beside me, sitting on the handle of my trowel and acting like three little shadows. As for feeding, they now trust me enough to feed next to my outstretched hand, but not yet from it. They sit on the arm of the bench, watching and waiting next to me. Trust is a huge thing for them and I have enough patience and time in my life to wait for them to become braver, should they choose to be. If not, then

I'll continue to enjoy their comical company as their parents raise a second clutch.

For mum and dad it's back to the business of beaks full of worms and grubs, in and out of the hedge, backwards and forwards. The cycle starts again and I wonder if maybe I'll have the privilege of watching more baby blackbirds flourish in our garden in the coming weeks. Already I feel like a proud parent to have witnessed the first two babies maturing in our garden, though it wasn't me doing the actual, physical work of flying backwards and forwards to the nest umpteen times a day. With their speckled brown feathers becoming darker by the day, and their wings growing stronger, they are now gone, flown the nest, off to make their own lives.

~

Time has passed again and this morning I've been introduced to two new blackbird chicks. The proud mum urged and called them through the cover of the hedge and out they clumsily popped, through the purple flowering woundwort and fruit-laden gooseberry bushes, squawking loudly. As the weeks passed by, so she became much braver and, eventually took mealworms from my hand and from the blue jug, and has even perched on the table in front of me, head cocked on one side and joining me for my afternoon cup of Earl Grey.

Her babies follow her everywhere and I marvel at how she breaks the mealworms up before feeding them to her small, demanding charges. At times she takes the comical pair down to the shallow puddle areas of the wildlife pond to drink. It seems she is showing them around the garden and all it has to offer. Day by day, the babies come to feed, becoming more trusting of me each time. Should my husband be with me, both mum and babies keep their distance or even stay completely hidden. It seems that their trust is with me alone.

It was while I was sitting down the bottom of the garden, looking over our growing meadow, that I noticed the honesty and forget-me-nots were past their best now. I made a note that the forget-me-nots would have to be pulled up, their seeds scattered in readiness for next year.

But the honesty could stay put until it had produced the paper-like seed discs it is well known for. The pretty little woodruff and the burgeoning comfrey were still producing new flowers though, so there was something to replace those plants which had now lost their colourful blooms. It was during this contemplation, as I stood and wandered around the garden, that the female blackbird followed me about, as if she was asking for the mealworms hidden in my pocket, her head on one side in a questioning gesture.

~

A few weeks have passed again and the male blackbird has all but become redundant. He sits alone on the shed roof just after four in the morning, singing for all he is worth. I think his wife has turfed him out and now doesn't want to

know him, but I appreciate his lamenting song, even at that early hour in the morning. Mum is still coming to feed but the babies, like the first pair, have flown the nest.

She will be outside the back door in the morning, where I've placed a plant pot full of soil and which I've adorned with old log pieces and a couple of calendula plants. If I put some mealworms on the top of the pot, she will feed quite happily while I potter about inside. Once finished she will busy herself in the garden, picking up worms and bugs. If she's still about in the late summer months, I know that she will be feeding on the berries hidden inside the leycesteria shrub at the bottom of the garden. Blackbirds seem to love what it has to offer and it's always been a favourite.

But this morning I opened the back door to see a sight that choked me up somewhat, as our beautiful mother blackbird has been injured after a fight with a jackdaw. She's hobbling about on one leg, sometimes standing on both but mostly just using the one. It breaks my heart to see her struggling. I watched as she stood there with her leg held up flat against her body, but quite able to stand firm on one leg, while not moving. Sometimes she would put her foot to the floor to have a short run but would more often than not take off from standing rather than have a run-up.

I thought back to the early evening of yesterday when there was a kerfuffle in the garden. I'd been tying the runner bean plants to their poles and there was a commotion at the top of the garden between the grey-

46

headed jackdaws and the blackbirds. It's a frequent occurrence and the blackbirds give as good as they get, as they protect their eggs. This time the noise was awful, the squawks were loud and angry and, as I went to investigate, I realised that there were feathers flying. As I approached, the shiny jackdaws flew off one way, towards the roof, the female blackbird towards the hedge. I can only think that's when the injury occurred as I recall I didn't see her much after that. I couldn't have got to them any quicker than I did but I suppose that's nature for you.

She's one feisty individual though and didn't look to be giving in. I've come to realise over the past few hours that she may be down, having had a tussle, but she's not yet out, as she's been with us in the garden all afternoon feeding on mealworms. It seems she feels safer feeding around us, than on her own. She's so very tame and obviously trusts us. I can only hope that it's nothing serious and that with rest, she will heal. We'll have to see what tomorrow brings but I'm thankful she doesn't have hungry mouths to feed any more and only has to fend for herself.

~

Time has moved on and the morning dawned miserable and chilly, but I was up and about with a cuppa before six o'clock. Flinging a sweatshirt on, I opened the back door, shaking my blue jug and softly calling "c'mon, c'mon", and there she was, swooping across the garden from the side beech hedgerow. As she landed beside the plant pot I noticed her leg was down, and she was using two legs to

stand on. I placed some mealworms on top of the soil and up she hopped with both of her little legs being used. I was so happy to see that the injury wasn't as bad as I first thought it to be and her leg wasn't broken. She doesn't yet use two legs all the time, but hopefully a bit more rest and time will see her right.

~

Another day dawned and I was awake to see the sun come up. Having opened the gingham curtains in our bedroom, my eye was drawn to a bright light in the sky. There were no clouds, no stars, and the light wasn't moving. It was y-shaped: two lights at the top and one at the bottom. After twenty minutes or so, I returned to the bedroom window to see if it had disappeared, as it seemed very mysterious. It was still there and as the morning sun appeared, climbing above the horizon, the light stayed put. When I returned for a third look, after tea and toast, it had gone. Swallowed up by the light or flown away, I wonder? I've never seen anything like it over Exmoor and some digging about revealed nothing. Very strange.

My early morning foray seemed to be earlier than usual this morning but I was quite eager to see if the mother blackbird was any improved. With my blue jug in hand, I opened the back door onto the garden and there she was, waiting in her usual spot and on two legs. She ran towards me, coming so far and then halting; waiting for her proffered breakfast. On two legs she ran, on two legs she hopped onto her pot, and on two legs she rested on the

fence, after devouring her early meal. It was so good to see her return to normal and I've been watching her all day, as she followed me around the veg patch while I weeded. As I pulled the culprits up, she foraged about in the turned soil, picking up small worms.

On going to collect some water from the water butt, I returned to find the blue jug upturned, the few remaining mealworms eaten, and a very satisfied bird giving me the eye. "I've helped myself", she said and I didn't mind one bit, because all was right in the garden; she was back to normal. Later on that day, I was preparing our evening meal when there was a scrabbling outside the open back door.

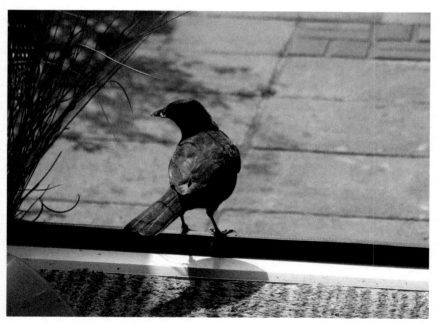

On investigation, I found that my canny blackbird friend had discovered where I'd hidden the blue jug. It's on an old, upturned, wicker bread basket, which is attached to our mini stick-store by the door. As I reached for my camera, she was on the sage green basket, head in the jug, just feet from me. It didn't end well, however, as the jug upended, the mealworms spread and bounced all over the step, and she flew a couple of feet away, wondering what was going to happen to her impromptu supper.

My garden shed is just over the way, so I went for a dustpan and brush only to turn around and catch her on my doorstep, pecking up what she could, as fast as she could. It's lucky I only keep a small handful of mealworms in the jug at any given time. I left her to it, smiling and shaking my head, although nothing should amaze me these days, living up here on the moor. I must admit though, that as I squeezed past her you could hear me muttering at her to let me pass, so that I could continue with my dinner preparation.

With the coolness of the evening upon us and rain forecast for the weekend, I decided to plant out my cosmos and poppy plants. They were both more than ready for the big wide world of the garden. I grabbed a bucket and my trusty trowel and trotted off down to the nursery bed to dig them up.

With my mealworm hiding place having been uncovered earlier, I'd left the little blue jug, with very few mealworms, on the stripy mat just inside the back door. I was thinking that my friend might visit one last time before bed. Passing

by the back door on my way round to the front garden, via the narrow pathway, I spotted movement out of the corner of my eye, and there she was, happily feeding away on the mat in our boot room, jug tipped over, mealworms everywhere, and enjoying what was probably her first venture indoors. Amazing.

~

The following morning, with the sun up and warm, I was awake and about early. I opened the back door as wide as it would go, propped it with my fairy wedge and put the kettle on. Remembering I needed to get bread from the freezer, I wandered towards the back door, thinking about my day, when, low and behold, there she was, patiently waiting for her breakfast in the boot room. My blackbird was standing on the doormat, indoors. I could have trodden on her!

With her breakfast served, I returned to make my tea, but she's been in and out all day long, not a care in the world and as bold as brass. I'm wondering if she will be waiting for me tomorrow.

~

As we sat outside this evening, me writing and my husband with a whisky, my blackbird perched on the shed roof, her warning call telling us that she was complaining bitterly about something and, like a fool, I was chatting to her and asking what was wrong. She came right up to our feet and, I kid you not, it was like a scene from one of the old Lassie films. With no jackdaws making themselves known nearby,

my husband spotted a red kite, soaring in the sky and not too far away. We wondered if she had spotted it too. By the time he'd grabbed his camera, it was making its way towards open moorland. Her warning call died down and things returned to normal for us all and our garden residents.

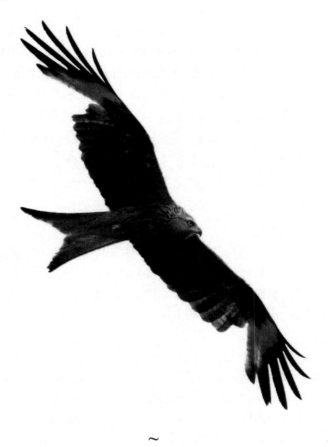

~

The warm days have passed and we honestly didn't think our mother blackbird had laid another clutch of eggs but it

seems we were wrong. On Thursday she introduced us to three new babies. They fluttered about, not making it far off the ground, and I feared for them, with so many jackdaws about. Their little tail feathers were practically non-existent, but this morning (Friday) they could fly up onto a trellis panel and back down again safely.

Poor old dad, once again, looks as if he's seen better days, appearing as if he's been pulled through a hedge backwards but he's there, feeding them together with their mum. She won't have anything to do with him though. All very interesting to watch.

~

With her third lot of babies up and gone, mum is feeding at the nest once again; we can hear the chicks but haven't yet seen them. She now regularly, and freely, comes into the boot room, perching on the bench or the faux chandelier light fitting, and she doesn't appear at all perturbed by the tinkling sound around her, made by the dangly bits, as she gets herself comfy up there. Our grandson thinks it's highly amusing that a wild bird visits us indoors. We do too, but it's lovely to see her trust.

As I sat down with a glass of deliciously fruity red wine tonight on the bench, enjoying the colours of the wild flowers, both the male and female blackbird kept me company. The male may have stayed in the background somewhat, not wanting to confront his wife, but it seems that safety in numbers (when you're not frequenting somebody's boot room) was the order of the day. Fingers

crossed they stay safe and that the jackdaws behave themselves. Only time will tell.

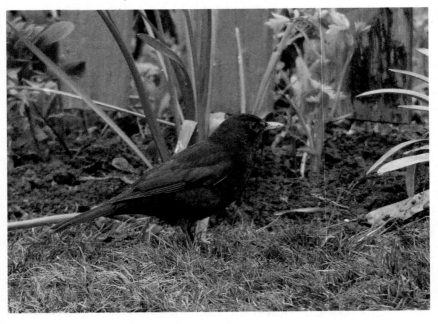

An Approaching Birthday

Today is the last day of June and my July birthday is bounding towards me at breakneck speed. Where did June go? With the hot spell of weather, followed by the intermittent rainy days, there's been a slight unseasonal chill in the air. So much so that I've witnessed smoke curling up into the grey skies from woodburners, having been lit once again. It appears that "flaming June" burnt itself out towards the latter part of the month.

I wandered across the damp lane this morning, before the onset of yet another shower, to rest my elbows on the gate there. As is usual I had my coffee with me, which I set down on the solid, square gate post. It was there, looking out over the moor, that my mind wandered to my birthday a few years back.

I'd spent the day giving an old gate a fresh coat of sage green paint, refreshing it for another year, and felt happy in my work. The summer sun was at its best and all I asked from the day was that my husband and I were together. Presents are not top of my list and I'm exceptionally easy to please. Knowing me well, my husband took me to the

best restaurant in Somerset; good atmosphere, good service, and an excellent view from where we were seated. I couldn't have asked for more. The restaurant was open air, we ate al fresco, and it was probably the best birthday meal I've ever had.

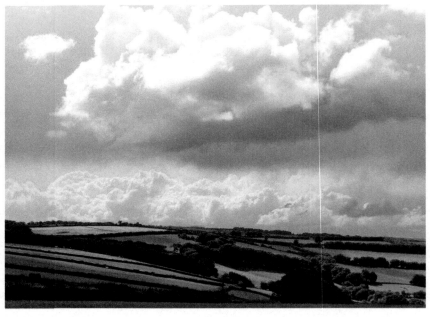

The restaurant of choice? It was up on the moor at Molland Common, overlooking Triss Combe, where we ate our fish and chips, with trifle for dessert, and all washed down with elderflower cordial. Sat in the boot of the car, looking out over the most spectacular scenery, we devoured our meal, unashamedly licked our fingers, and watched the sun go down before returning home. Those are the best birthdays: simple, peaceful, and in a place where I love to be.

Having finished my morning coffee, and shaking my head at my reminiscing, I headed back over the lane to put away the baking that I'd produced earlier. At around half past ten I normally headed up the road to help muck out a friend's six stables, taking freshly baked cakes, biscuits, or bread with me. As it had been warm of late the horses would have been out in the fields, the cool stables standing empty, but I'd still have lunch with my friends as I often did. Today I had a tasty, and very easy to bake, loaf of caramelised-onion bread, wrapped up in a tea towel, to have for lunch with some cheese. I pulled on my yard boots and set off.

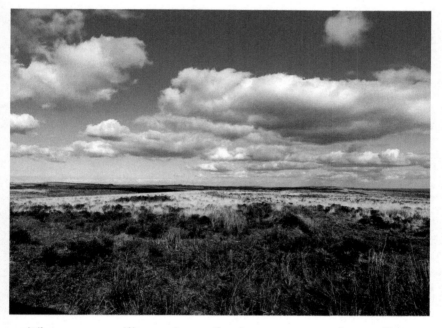

There was still no sign of rain as yet, so the walk was quite pleasant. Rain doesn't bother me though. Fair

enough, it makes you wet, and some rain makes you wetter than others, but you soon dry, and nothing is lost. If I was concerned about being soaked, then I'd never set foot outside the back door of the cottage.

Sometimes I'd approach the stables from the back way in, across the fields where the horses grazed happily. Walking up the lane is a totally different experience to that of crossing the fields. On either route I'll get lost in my own world, as I take in the hedgerows that I know so well. I'll see the gaps made and used by the wildlife, an abundance of colour with the wild flowers, and pass one or two Somerset County Council signs adorned around the base with frothy cow parsley waving gently in the breeze.

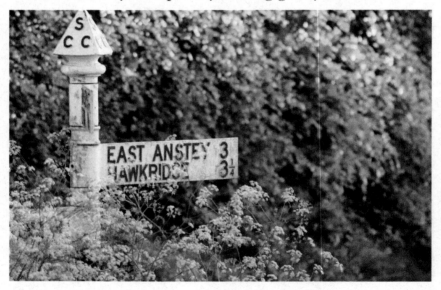

On the lane my feet walk on tarmac with the dull tap-tap of my boots keeping me company, always aware of vehicles that might be approaching from around the

winding bends. Over the fields my footsteps are quiet as the soles of my boots touch grass, and I don't get interrupted in my thoughts as I often do walking the lanes. I'll often stop in a gateway and peer over a gate, looking for the wildlife. It's been known that I'll even stop to gaze at a view. Goodness knows there's enough of those about on Exmoor.

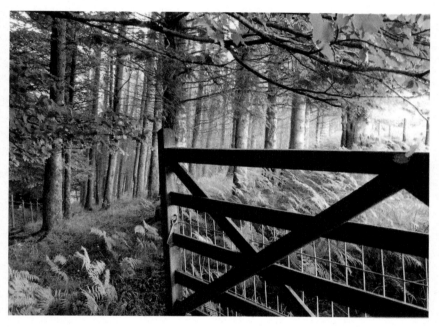

Eventually reaching the stables, I'd pop a Polo mint in my mouth and call out "cooeee!" to hail my arrival. If there was no sign of movement in the yard or stables, I'd creep in and start work alone. With the chirping sparrows up on the rafters and swallows darting in and out through the wide doorway, I'd work quietly through all six stables, mucking them out, barrowing the manure, replenishing the

hay, and cleaning water buckets. Swiftly I would work, while humming or singing away to myself.

I do love to sing while I work wherever I am, but in the stables especially, where the smell of horses and fresh hay pervades the senses. It's a place where I'll always feel happiness. However, if, when warbling out a song, I'm not sure of the words, then I will la-la-la to my heart's content until I come to a bit that I do know the words to. Henceforth, my friends affectionately nicknamed me La-la.

This name sometimes causes confusion with people mis-hearing an introduction and consequently calling me Ga-ga instead. Sometimes I think they've sussed me out just about right; if they could see me leaping about the yard with two branches held to my head, acting out a wonderful impersonation of a majestic stag, I think they just might nod in understanding.

I was allowed to drive the old yellow dumper truck, once, which transported the horse manure down to the heap in a nearby field. After unskilfully coaxing it through the gate, it promptly sprung an oil leak in a hose, spurting black oil at me and all over the friendly and mud-covered wheels. It had been years since it had broken down or had a problem

and, needless to say, I wasn't allowed near it again. Back to the trusty green wheelbarrows for me, then!

When I'd finished the mucking out, if I still hadn't seen anyone, I'd leave a large note on the wide, metal gate which said 'Happy Tuesday!' or whatever day it was. Leaving my bake of the day safely out of harm's way in a mutually known spot, I'd creep back home again, knowing that they would love and appreciate my gesture. That's what friends are for: to sometimes make life a little easier with a helping hand and a smile. So, either alone or together, the stables would be tackled and the yard swept, with a welcome cup of tea and lunch to follow when the task was finished.

I count myself very lucky to be able to help with the horses. My family on my dad's side always had horses and way back in the 1930s there was a greengrocery and a coal round in the family, all delivered by horse and cart. My uncle, who I was very close to, had a rag-and-bone round that he worked with two horses called Rosie and Sam. As a child I would proudly sit perched on the red bench, holding the shiny leather reins, while my uncle collected scrap items and clothing from the

houses along the roads. "Any old lumber!" was a phrase I learnt to call out, along with my weathered uncle, from an early age. Going further back, my ancestors were grooms, ostlers, and agricultural farm workers using horses in the fields, and here I am, hundreds of years later, still happy to help muck out and be with horses.

Lunch time was done for another day and while we sat devouring the onion bread with cheese and ham, together with a welcome cup of tea, we put the world to rights. On my way back to the cottage, I took a detour across the more distant fields, as the deer have been visiting in large numbers. With there being forty to fifty at any given time, they're making the most of feasting on the grassy fields. I thought it would be good to see them before they have to

be persuaded to leave for a couple of days, while the fields are cut, ready to become black-wrapped hay bales for the coming year. I'll be spotting again soon enough, when the bales are ready to be stacked.

Approaching slowly along yet another beech hedgerow, which is interspersed with hawthorn bushes and willowy, purple foxgloves, I tried to keep my head below the height of the dense hedge. Knowing the fields well, I was aware of a dip in the hedge line underneath a huge, spreading beech tree. When the rut is on, the beechnuts that fall from that tree make it particularly difficult to creep about as they crunch and snap underfoot. Today, though, my feet were as silent as they could be, but if there were any deer grazing in the field, they would be very aware of my presence. I

hoped I could get a good sighting if I could keep out of sight myself. If they became spooked, they'd be making a dash for it, bouncing over the fields and away over the fence.

In the adjacent field several horses were taking shelter under a copse of trees, their heads hung low, one foot tipped up and resting on the ground. I could hear them exhaling as I walked slowly by and noticed the flies around their heads, causing them to shake their manes every now and again. It was dark and shady under the group of trees but sunny and bright on my side of the hedge, a natural contrast if ever I saw one.

Reaching the corner of the field, I was able to see a scrubby field to the right of me, where grazing isn't as good as the other surrounding fields. There are sometimes deer to be seen here but it's usually used as a back-up or escape route for them, down towards the woodland. The fencing is down in places where the lithe deer have leapt over time after time, and there are run-throughs up and over the high muddy-banked hedgerow. Deer slots of differing sizes can be seen all along this stretch, but there was nothing doing in the field today.

I followed the line of the hedgerow and, several feet along, I peered through the bramble-clad branches, the small fruits a promise for the later months. There was still nothing doing so I stealthily soldiered on towards the dipped hedge line. It was there that I would get my chance. Right before the dip sits a large, grey, beech tree stump. This is what I used for cover and where I would keep a low

profile before retreating, should there be deer about. We've used this spot time and time again and have always been able to remain hidden from sight if the wind was with us, giving us enough time to watch for a while. My only problem was if the deer had decided to come right up to the hedgerow, which they have been known to do, then they'd be off like a shot, only to return later when the coast was clear. But, fingers crossed, they were feeding towards the centre of the field, and all would be well.

It was difficult where I was stood as the ground sloped away and down towards the trees. Deer could be out there but, with grass this tall and coupled with the slope, they'd have to lift their graceful heads in order for me to see them. If the stags were to join the hinds then we'd at least have a bit more height to focus on, but they've not been seen for a couple of months hereabouts; it's just been the ladies and one or two young and very pretty calves. With the grand and very substantial tree stump in front of me, I crouched down to slip a camo net over my head; it smells, but it does the trick. My husband always has pleasure in telling me that my blonde hair stands out like a lighthouse beacon as we walk the fields. He's right, of course, but it's never really prevented us from seeing the wildlife that we do, and I'll always cover up my head of lighthouse hair if we're on a mission.

Slowly lifting my head and peeking out around one side of the stump, I couldn't see any sign of the deer as yet. My eye line needed to be a little higher, so slowly I began to move upwards – and there they were. Only spotted when

two hinds lifted their heads for a check around the field, I then had sight of them and realised it was quite a large group. One by one, taking their turn, they would lift their heads, still chewing the grass they were feasting upon, have a look around, and continue their quest. Goodness knows how many were sitting down amongst the cooling grass; their flattened indents left in the grass would tell a tale at a later time. Although I couldn't see all of their form, the beautiful red deer hinds looked peaceful and content and quite happy to feed on.

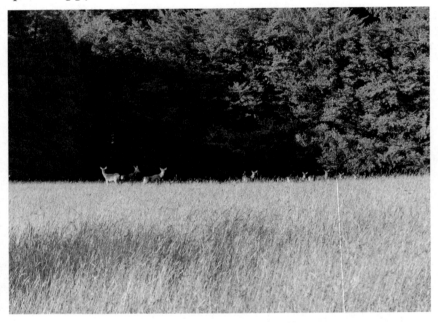

I stayed watching them, dallying while the weather couldn't make up its mind what to do. They are the best days, and I love that I can walk a while and see sights such as what I'd witnessed that afternoon. I retreated slowly and

carefully, walking backwards until I could raise myself and remove my camo net. Shoving said smelly camo net in my pocket, I thought that it badly needed a wash, but knowing that the idea was a big no-no if I wanted to see more deer up as closely as we did, I patted it down even further into the depths of my pocket, leaving it to reign for another day.

With the weather holding, I had my own chores to do this afternoon. So, stepping out, I crossed the fields along a narrow track, with a spring in my step. Back in the coolness of the cottage, I patted the worktops as I usually did and placed a plain old Americano coffee pod in the machine. I waited for it to slurp and whoosh to its finish, grabbed a date and apple slice from the cake tin and wandered outside to the bench by our small wild flower meadow.

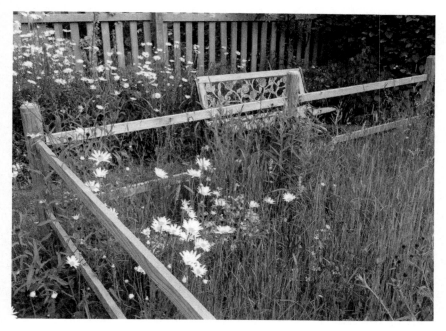

I'd make the most of the day, while the sun flitted in and out of the fluffy white clouds hanging in the grey-blue sky. Placing my coffee on the wooden slats of the bench, I put my booted feet up on the rail. I'd carried with me a small jug of mealworms in case my blackbird friend came to find me. A soft breeze wafted the green stems of the swathes of grasses and wild flowers, settling me with a calmness that I wished I could bottle and send to my friends.

It was only a matter of time before I'd have to rise from my resting place and get on with the day, yet I knew that I'd sit there and contemplate that birthday of mine, coming at me at full-steam ahead. Yet another year would have passed but there was another glorious year ahead of me. Age is just a number and I had a lot to be thankful for in my life which I'd never take for granted. Not everybody could live in a place as beautiful as where I lived and I counted my blessings as I sat there. Birthday or no birthday, I was happy with my lot. Very happy indeed.

Windy Wildlife Wandering
(Thoughts from Yesterday)

Today is one of those days when you itch to venture out in the open air. However, you know that you're going to get a soaking if you do, let alone get blown away – not by the fantastic scenery, but by the wind. Exmoor at its finest!

As I stand and look out of the study window, I can see right across the moor. It's bleak, it's misty, it's drizzly ... It's "mizzly" but, conversely, it is beautifully atmospheric. I know what the weather is hiding, and I also know that it will still be there when this awful run of weather has passed.

Exmoor keeps me feeling alive and positive, whatever it throws at me. Later I will venture out; I cannot and will not stay inside all day. At the moment, my garden umbrella

is legging it across the adjoining paddock, dancing in the wind. I'll go and retrieve it after lunch and stake it back where it belongs – it can do no harm at present.

Over in the corner of the paddock is the distinctive aroma of foxes. There, in a marvellous triangle of wild flowers – red campion, buttercup, ox-eye daisy, and fern – a pair of foxes are bringing up their young. I am sure of it. The scent is strong – too strong for a passing fox to have made – and I've seen one of the parents parading through the short grass, healthy tail, white-tipped, brushing the ground. I have also been the receiver of small parcels on my steps and around my raised vegetable beds for some time now.

Across the field I can bear witness to the high winds, as the beech trees, resplendent in their new greenery, wave and toss their branches about against the grey sky, every branch and twig being blown towards the north. It's a stark sky but the green against the grey clouds is pleasing enough. It's a sad sight to see that the lane is strewn with leaves ripped from these glorious trees – they've only just emerged and yet have fallen foul to the weather already. Plenty more where they came from though, as well I know from collecting them during the autumnal months.

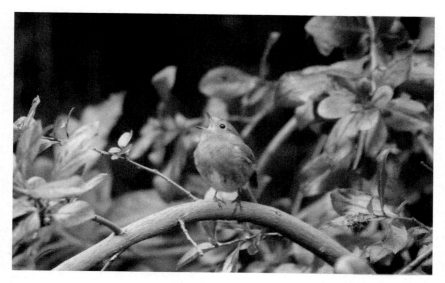

It seems that my resident birds are not put off by a touch of wind and rain. The robin is still milly-mandering about on the raised beds, looking for a tasty morsel. He moves from post to post quite methodically and eventually ends up on the corner of the topmost raised bed. I'm never alone when gardening and the robin will keep me company each and every day. He will sit waiting for me to turn the earth, and can always be seen atop my garden fork should

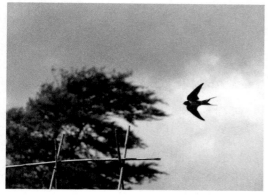

I leave it to stop for lunch.

It really is a grey day, with the clouds scudding across the sky at quite a rate. I thought it would have passed a little by now but, no, I

have to be patient a little while longer. The swallows, however, have no patience as they whirl about the sky, standing out like silhouettes as they flit about. Their song isn't as orchestral as it has been on warmer days, but they're still there, fighting to feed their young. I expect to see their podgy fledglings soon enough, lined up on my cherry tree, waiting for lunch. If the wind catches the parents as they pass by the window they stutter in their flight, but are masters at regaining equilibrium and are off like jets across the paddock. Amazing to watch, whatever the weather.

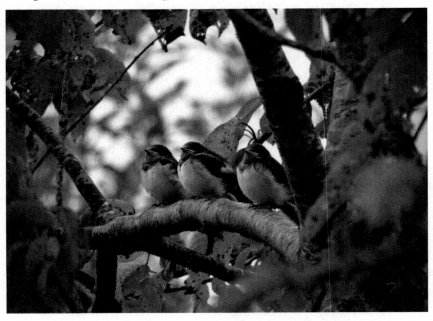

In a terracotta urn full of twigs that sits under my dining room window, an innovative pair of blue tits are nesting. I watch in awe and amazement as they fly to and fro with beaks full of insects and small caterpillars. The nest is well

hidden from view, right down in the pot. I've tried, very carefully, to see it by opening the window and peering in, but no joy. On returning to the nest, if they suspect someone is watching them, they will land on the fence, edge their way along quite nonchalantly, and then dive into their hideaway! It's so funny to watch them and I've tried to catch them on camera but am fearful of scaring them from their young. It comes down to that 'patience' word again and I'll have to wait and watch for the little ones to leave the safety of their home in order to photograph them.

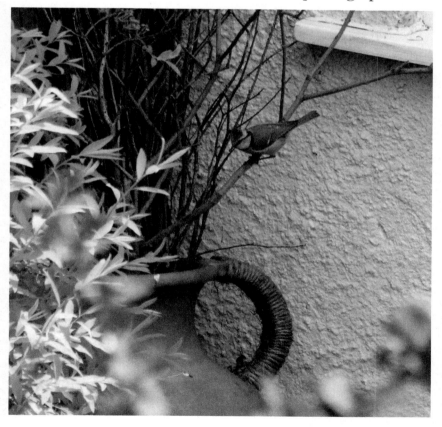

I've been up the lane for a short jaunt this morning already, fighting against the Exmoor mizzlies of drizzle and wind. There are puddles sitting in the gateway, twigs and small branches litter the drive (good starters and lighters for the winter fire!) and the sheep have stopped their calling.

Sheltering under the hedgerows, the ewes and lambs have taken refuge while the worst of the weather passes by. Quite sensible, I'd say, but I do miss their bleating – it's normal background noise for me. No planes, no trains, no HGVs – just noises of the countryside and all quite relaxing.

Across the way is a field which is given up to sheep but they've been moved for the moment. Behind the gateway I spotted two small baby rabbits sitting quite still in the drizzle, but easy to view from the lane. I expect they'll bestow their presence upon me one of these fine mornings! Hopping across the lane, the babies will come up alongside the cottage, use the steps as a place to groom themselves and then probably find my carrot tops! I don't mind; there's enough for

everyone and I'd rather have them in the garden than out on the lane, open to all sorts of danger.

~

It's after lunch now and I've been out to brave the weather and, hey-ho, while I've been off across the fields the weather has broken. Rain has ceased, winds are still blowing a hooley but the sun is breaking through. I'm a mess, my hair looks like a deflated meringue and I'm damp but it was refreshing to be out and about.

My camera came with me but it was hard to keep it still in the wind. I'm up high, here on the moor and, although protected around the cottage, out in wide open spaces it fair-by takes your breath away! But look what I found on my travels. Sheltering against the hedge line was a small herd of red deer. With my camo coat zipped high and an oversized hood on my head and most of my face, they were oblivious to my being there. What a wonderful way to spend half an hour, leaning against a gate in weather such

as we're experiencing today. I left them, safe from the elements and tucked into the edge of the field, to make my way back home to the cottage.

My walk back was much more friendly than my outward journey and I could stop awhile to admire the wild flowers and greenery. Red clover punctuated the fields

of buttercups and grasses, and cow parsley decorated the hedgerows, with the ferns, at last, unfurling to make the most of the damp weather.

As I am taking the Wildlife Trust's '30 Days Wild' challenge, I thought I'd refresh the pile of small logs at the front of the cottage. I've had it in place for a couple of years now and always replenish the pile each year. The small, gnarly branches are ideal for creating hidey-holes and crevices for residential use. Apart from topping it up I don't touch or interfere with the pile, unless it's required. Having blown the cobwebs away and taken in some air, it's now back inside the cottage for a welcome cuppa. No cake today though: baking day is tomorrow this week, unless the much-talked-about Somerset heatwave hits us. Can't quite see myself tied up producing cupcakes while the sun shines!

So, I'm back in my seat overlooking the moor with a cheeky magpie to keep me amused by banging and pecking the slates above the window. Magpies, although naughty at times, are one of my favourite birds (although I admit to having quite a few favourites.) When I was small, my brother brought a fledgling home, whose parents and siblings had been shot. She was raised by our family and lived with us for eighteen months before meeting a mate

and leaving us to live freely on heathland. Her name was 'Maggie'. It's no wonder, then, that magpies, with their stunning plumage, hold a special place in my heart. The mere sight of them evokes childhood memories.

The sun shines now; the wind is still breezy. Herbs, in all their splendour, call to be planted out and given room to breathe. Looks like that's my job for the next hour or so then. I'll take my tea with me, rescue the escapee garden umbrella, and see if the robin will keep me company for

the rest of the afternoon. There are fairies at the bottom of the garden — perhaps I'll see them too!

Oh, to be out and involved in simple pleasures. It's hard to top them when you live in such a stunning place.

An Unusual Night

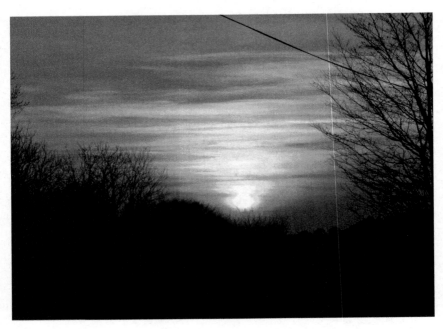

My eyes ping open and I try to focus on what has woken me up at two o'clock in the morning. I'm sure it was a noise but, in my half-awake state, I can't be sure. Lying in the darkness of the room at the front of the cottage, I strain my ears to hear anything that may have caused the interruption to my slumber.

Nothing; absolutely nothing.

It's as quiet as dreaming trees out there. Maybe *I* was dreaming! I turn over, closing my eyes, and hope sleep will come. But there it is – an alien sound, ringing out through the near inky blackness in the lane. Swinging my legs out of our warm bed, I silently pad over to the window and listen. There's not much to see, but with the half-moon waxing I do at least have a small glow of light to help me. Her semi-brightness shines down on the damp lane outside the cottage and lights up the gateway, where our five-bar gate sits, protecting the garden.

Deciding to open the window, I lift the curtain a little more and deftly duck underneath. I wonder why my "sleeping partner" hasn't yet been disturbed as I have been and, wishing not to wake him unnecessarily, I gently open one of our old, wooden windows, perch on the sill, and wait. It's then I realise that the noise is of someone singing. Someone who sounds the worse for wear, and whose words are so slurred that it's impossible to understand them. A singer, in the dead of night, up on the moor? I've never heard such a thing but, there again, I lead a very sheltered life! The singer is drawing nearer and his lilting voice is broken every now and again by him calling someone's name, quite loudly.

Still I wait, now intrigued as to what I'm going to witness, as my husband sleeps on despite the antics outside. I wish I could hear what he is singing about, as his voice is haunting, coming through the darkness of the night. It sounds like an old Somerset folk song and, to be honest,

as tired as I am, I'm quite enjoying the entertainment! Then he's there, a tall, wiry man, crossing the moonlit gap in front of the gate, staggering and zigzagging up the middle of the lane. A black-and-white collie runs alongside him, his faithful friend, obviously the owner of the name that he's continually calling out at random intervals as he sings.

This is all very odd indeed. Where has he come from and, more importantly, where is he going to? The nearest watering hole is about four miles away in one direction, and in the other, it's miles and miles of open moorland with not a public house to be seen. He's come from the direction of the moor, and as our nearest neighbour is at least a half mile or so away, goodness knows how far he's walked. The plot thickens and his voice begins to fade, as

he goes on his way. There's silence again but then I hear the telltale click and creak of the battered old gate up the road. It's distinctive – I know the noise well – and our man has managed to open it in his drunken state. It's not an easy gate to manoeuvre when you're sober, so goodness knows how he's managed it.

For once I find myself cursing the tall beech hedge that borders the front garden and is blocking my view. The frustration at not being able to see is making my ears listen all the harder, and what I don't hear is the gate being clicked shut again. Knowing that it opens onto a narrow stretch of grass and that the sheep are safely penned in an adjoining field, I'm not that worried about the gate. However, I am concerned that our singer is going to come to a dead end as the narrow stretch of grass is eventually halted by a dense beech hedgerow. So, will he simply take a pew under the hedge and sleep it off, I wonder? I can still hear him singing, but it's distant now and I feel I should climb back under the covers beside my still-slumbering (which is unbelievable) husband, and get some rest.

~

By seven o'clock we are both awake and drinking our tea, with the curtains pulled back, as is usual, bringing Exmoor into our bedroom. Cross-legged on the duvet, I'm explaining to my husband about the events of the night, and he's trying to convince me that it was all a dream, as he didn't hear a thing.

Suddenly, out on the lane, there's a clattering of horses' hooves on the tarmac. I'm pretty sure that horses shouldn't

81

be travelling at that speed on such a hard surface. They definitely sound riderless. We are up and out of bed at once, as this sounds like an emergency situation. After a quick phone call to our nearest neighbour, who has also heard our equine friends, we find ourselves out on the damp lane.

Closing the gate behind us, we soon discover that there are three horses loose and cantering up and down the road. It's not the first time. There's the unmistakable rumble of a tractor coming from one direction and, knowing that help is at hand, we stand and block the scrubby lane that leads down to the woods.

Coming in the opposite direction are two people, whom we recognise, on horseback. Once they've turned the corner, they also stay put along by the gate with the telltale click. With the blue tractor now slowly bringing up the rear behind the horses, I cross my fingers and hope that the adventurers will now find themselves boxed in and will go calmly through the open gate. Knowing their game is up, they give in with little fuss. Here they can be safely captured and returned to their field a couple of hundred yards down the lane.

It transpires that someone left the gate to their field open last night, hence the round-up this morning, and I think we can all make an educated guess at who the culprit was. Which begs the question of how did he get through that dense hedgerow at the end of the narrow stretch of grass? But he must have done somehow because he'd then find himself in the field with the horses, which he'd

obviously let himself out of too, without closing the gate behind him!

Who was our mystery singer on Exmoor, and where had he come from? More importantly, where's he to now? I'd have money on him having a corker of a hangover this morning, and perhaps having a few leaves and twigs adorning his attire too.

It's supposed to be peaceful in the countryside, but it was a very unusual night, leaving us with many unanswered questions: questions that will probably never be answered.

With trouble averted, the horses safely back where they belong, and us back in the kitchen at the cottage, I turn to my disbelieving husband. "So, I was dreaming then, was I?"

With a wink, he replies, "Let's put the kettle on and I'll make you a lovely cup of tea."

Mm … an apology if ever I heard one, but it was the best cup of tea I ever tasted!

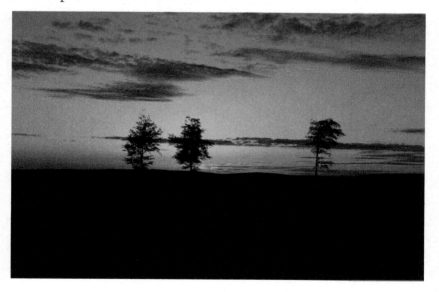

A Priceless Treasure

I had a visitor to the cottage some days ago. Nothing unusual in that, but this was a special person, who enlightened me a little as to how the cottage was many years ago. In my eyes, that's a priceless treasure to hold close.

Out of the blue, on a glorious hot afternoon as I worked in my garden, pottering about with a few weedy things, a kindly gentleman came to call. He asked if he could take a quick look at the garden to see if it had changed much since he'd lived in the cottage. I smiled, as did he, and instinctively knew that this was going to be a special few minutes.

My visitor had a broad Somerset accent and explained that he'd been born in the cottage some ninety-two years ago! I'd never have guessed his age to be anywhere near that figure. He climbed the few stone steps, which lead to my colourful garden, without a thought to his bones or body. The steps were as he remembered and I wondered how many times he'd climbed them before as a child and adult alike.

I felt quite a proud gardener as we leant on the paddock fence and took in the scene before us. To witness the stranger's face as he looked around him at the bursting

Sweet William, roses, herbs, pinks, and a wild array of misplaced cottage plants, was a magical moment. I've longed to meet him, because I knew of him but had no idea, however, that he'd been born in my cottage, so full of history, of character and stories – yet to be known.

I'd been told of the man who had once lived here and who had loved his flowers and vegetables. Neighbours had said that he would be pleased I'd taken his patch over, tending it with a love that only gardeners can understand. And here he was, standing with me at the fence, looking over my handiwork, and he was in a world of his own.

My gentleman explained that the paddock had been full of vegetables grown by his father and carried on by him. His parents had kept bees in the far corner, with several bee hives. There had been no running water and no electricity, and with an outside toilet, in the still-standing outhouse a little way from the cottage, things seemed tough. But to him, it was a life well-lived.

The outhouse is now covered in succulent ivy, which curls around a green man tile. At the moment it houses a multitude of useful items but I guess, like the cottage, it would have its own story to tell. I was trying to explain to him what the cottage means to me – how it has tales in its walls, how its heart beats if you stand in the hallway and listen carefully, how its character is built from those that lived here before me. He smiled and nodded and I knew he understood where I was coming from and that I wasn't away with the fairies at the bottom of the garden, like most people think I am.

I asked if he'd like to come look around inside. He welcomed the invitation. I learnt that there had been no kitchen extension back then but the bank of shrubs and

flowers up to the garden was still intact. A water pump outside the now dining-room window had long since disappeared, but he recalled his mother pumping water from it with a clear memory – back then, it would have been outside the kitchen door. The well, we know, still remains but is hidden now with stone slabs and gravel. My dining room was his kitchen and he could see his mother sitting in a chair before the large stove in the corner. Where my book shelf now stands there was a dresser and beside that a table running under the window. Under the stairs was their only larder and food store. It now houses my own store cupboard, but in a very different manner to what was there originally.

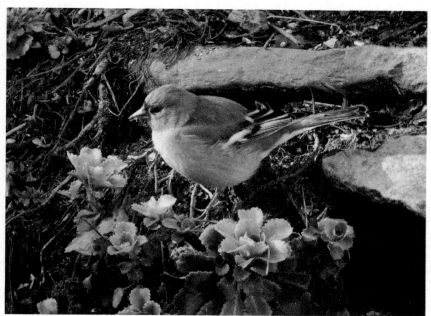

On the walls, their light came from mantles with chain pulleys that could be pulled one way or the other to increase or decrease the light, and he remembers a tiled floor in the porch, which is now our boot room. In the corner of the lounge there is a cupboard that houses my excess crockery; he told me it was originally there, all those years ago, but it used to house the jars of honey collected from the bees. I was amazed to realise that the cupboard had been there all that time.

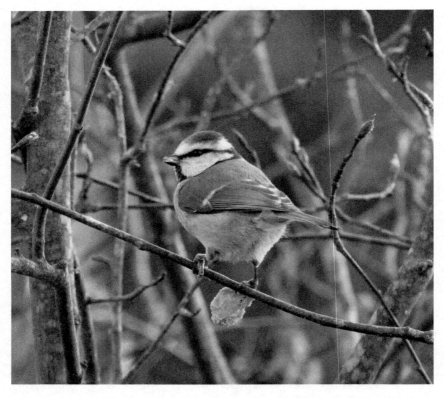

He marvelled at the chaffinch and blue tits feeding at the table outside the kitchen window, but most of all he

took pleasure in knowing that the old holly tree was still standing to the side of the cottage. It is my special holly tree, as it has ivy twisting and twirling all the way up the trunk and I love to look at it, to chat to it, and ask for its protection. Again, to think that the special tree has stood for quite a number of years is a revelation to me. You can instinctively know these things but it's always good to have it confirmed.

As my gentleman thanked me for my time, I thanked him for his stories and told him I'd look after his cottage. It all goes to building up a picture of what life was like here on Exmoor those ninety-two years ago.

He hesitated outside the back door, looking around him and said, "Well, I never thought I'd be tinkling this way ever again. Thank you so much – it's wonderful, just wonderful!"

It made me wonder about things that happen when I'm on my knees working in the front part of the garden. I'm not far from the old, wooden five-bar gate and I often have feelings of being observed in my work. Anyone can pass by the gate – walkers, riders, cyclists – but this is a different sense of being watched. Several times I've turned slowly, trying to catch whoever it is who keeps an eye on me and, believe me or not, I have caught a fleeting glimpse, more than once, of an old man in a rather too large cap, baggy trousers and shirt (his sleeves rolled up around the elbow) with braces, leaning on the gate in a relaxed manner.

Chatting to those who live around me, but not letting on what I've seen, it appears that a previous owner used to stand at the gate once or twice a day, nodding at passers-by. Whether my company on those special days was my kindly gentleman's father or another previous occupant remains to be seen, but I know he's there and keeping an eye on what I'm doing in the garden. I cherish times such as that afternoon visit.

There's always something happening around the cottage to make me smile and I know in my heart of hearts that some things will never really change; they may develop a little, but they'll never really alter that much where I live.

I'm happy to exist on a mixture of both the old and the new as I go about my daily business here at the cottage,

and I'll look after the memories and stories for those that will come after me here in what is, for now, my special home, my little bit of Exmoor.

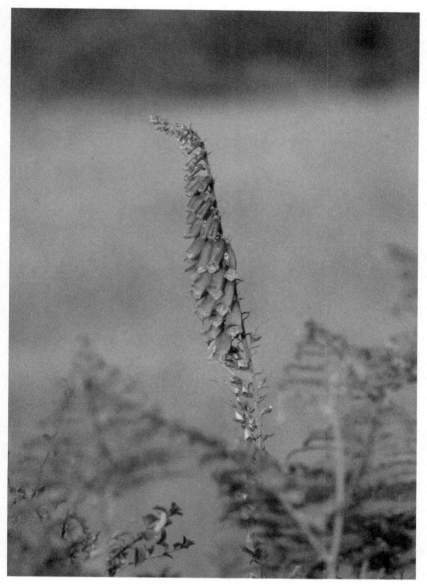

Here is a Fence

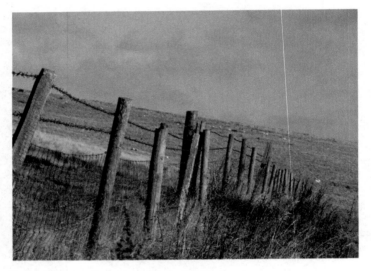

Here is a fence. It's a simple fence.

It's a fence that keeps cattle and sheep safe.

It's a fence that buzzards use, to land on before taking to the skies once again.

It's a fence that kestrels hover over, looking for their next meal.

It's a fence that the hare uses as cover, as it crosses the lane in the evening.

It's a fence that we take coffee and cake by, on our jaunts across the moor.

It's a fence that we have bacon sandwiches by, on our early-morning ventures.

It's a fence where we've watched the short-eared owl fly.

It's a fence where we've witnessed a distant hailstorm whiten the fields one by one.

It's a fence that takes the eye way across the stunning Devon hills and fields.

It's a fence that affords outstanding sunsets in glorious hues, and

It's a fence where the red deer can be seen silhouetted against the evening sky.

Here is a fence … but it's not just any fence. It's our special fence, high on the moor, where it not only enfolds the sheep and cattle, but our memories too.

Here is a fence.

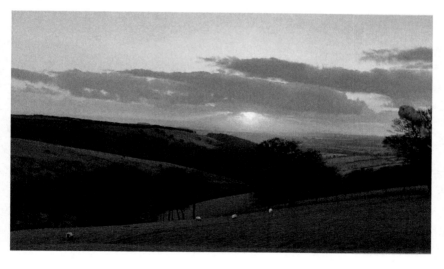

A Note on Flower Names

Ellie lists a fair number of flowers, trees, and animals in the text of her stories. While most of these are fairly well known, I noticed, while producing this Summer edition, that I was not myself familiar with many of the wild flowers listed herein. So in case any readers are as ill-informed as I am, here is a list of some of them with their scientific names. I feel sure my grandfather, Frank Kingdon-Ward, in whose honour Blue Poppy Publishing is named, would have approved.

I know I will have missed a few out, but I hope that will cause readers to berate me and, thereby, I will know they read the book. I have included some of the more obvious ones, too, but I hope you do not feel your intelligence is being insulted by the inclusion of, for example, daisies.

Bluebell – *Hyacinthoides non-scripta*

Buttercup – *Ranunculus* various species

Comfrey – *Symphytum officinale* and other species

Corncockle – *Agrostemma githago*

Cornflower – *Centaurea cyanus*

Cow parsley – *Anthriscus sylvestris*

Daisy – *Bellis perennis* and other species

Forget-me-not – *Myosotis scorpioides*

Fox and Cubs – *Pilosella aurantiaca*

Foxglove – *Digitalis purpurea*

Honesty – *Lunaria annua*

Lesser celandine – *Ficaria verna*

Mallow – *Malva sylvestris*

Mayweed – probably *Anthemis cotula*, a.k.a. stinking chamomile. Possibly *Matricaria sp.*

Primrose – Usually *Primula vulgaris* but other species exist, and it is not impossible for certain hybrids to spread from gardens.

Purple vetch – *Vicia sativa*

Ramson – *Allium ursinum* a.k.a. wild garlic, cow leek, buckrams, wood garlic, bear's garlic, etc.

Red Campion – *Silene dioica*

Red clover – *Trifolium pratense*

Sweet William – *Dianthus barbatus*

Teasel – *Dipsacus* various species

Wild carrot – *Daucus carota*

Wild Garlic – See Ramson

Wood anemone – *Anemonoides nemorosa*

Woodruff – *Galium odoratum* a.k.a. sweet woodruff

Yellow rattle – *Rhinanthus minor*

About the Author

Ellie is the wrong side of sixty (her own words). She is married with two grown-up children, loves to be outdoors, and now lives on Exmoor with her husband. Originally moving to Somerset in 2004, she began writing thoughts about her life on the moor around 2013, a year before her youngest grandson was born. She felt that she needed to start a diary of sorts: in this way all three of her grandchildren would be able to learn what her life was like on Exmoor. Not having that kind of information about her own parents or grandparents, it spurred her on to making a record for them, so that they, too, would fall in love with the place where she lived. Writing from her Exmoor cottage, a cup of lemon-and-ginger tea to hand, together with a slice of homemade cake, Ellie knows that she has come home.

Acknowledgements

My husband accompanies me when we are out and about or simply working in the garden. He's less available when I'm cooking, although he does appear when it's tasting time. It is mostly thanks to him that we have some wonderful photos to bring my words to life; he is a diamond and also the glue that holds me together when my confidence fails me.

I must thank the custodians of the cottage whence I've penned my stories. They know who they are. The cottage is the heartbeat of my words and without its presence, and their understanding, I may not have started writing at all.

I cannot go forward without mentioning the inimitable Johnny Kingdom. He was an inspiration to my husband and me as well as a good friend. The kindness he showed, and knowledge he imparted, is everlasting.

My final thanks go to Olli at Blue Poppy Publishing. Thank you for seeing something in my words that others couldn't or wouldn't. You have made me smile, jump up and down, and cry, all at the same time, and I cannot thank you enough for giving me the chance to have a book published for my three amazing grandchildren; your help has been priceless. Sink or swim, it will be a legacy left for them, for always.

About Blue Poppy Publishing

Blue Poppy Publishing is a small independent publisher with big ambitions. It started in Ilfracombe in 2016 when Oliver Tooley wanted to give his self-published novel an air of credibility. The name was inspired by Oliver's grandfather, Frank Kingdon-Ward, who famously collected the first viable seed of *Meconopsis betonicifolia*, the Himalayan blue poppy. Blue Poppy Publishing now has dozens of titles by twenty or more authors but still has a way to go to compete with the big guns.

As a small business we depend on word-of-mouth far more than others so please, if you have enjoyed this book, tell others, write a review, blog about it, post on social media.

This book is the final one in a four-part series, with one title for each season. *Autumn, Winter,* and *Spring* are also available online or from all good UK bookshops.

If you enjoyed reading about Exmoor in summer then why not add the remaining three books in the series. Each volume includes many more stories of life on Exmoor, accompanied by more of Ellie's stunning full-colour photography.

Autumn ISBN: 978–1-83778–001–3

Winter ISBN: 978–1-83778–002–0

Spring ISBN 978–1-83778–003–7

Order from bookshops worldwide, or direct from www.bluepoppypublishing.co.uk

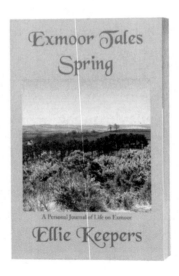

Printed in Great Britain
by Amazon

36765976R00066